find

your

voice

find
your
voice

—

A Guided Poetry Journal
for Your Heart and Your Art

noor unnahar

CLARKSON POTTER/PUBLISHERS

NEW YORK

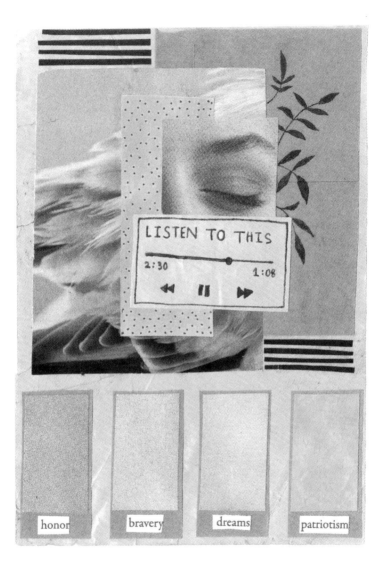

LISTEN TO THIS

2:30 1:08

honor bravery dreams patriotism

Find Your Voice will take you on a creative journey, weaving words together to compose poems that illuminate your true writing style. In this guided journal, you will not only find thoughtful writing prompts inspired by your daily life, but you will be encouraged to create collaged artwork for enhanced visual storytelling.

Your journal is split into three parts: Part I greets you with simple prompts to guide your wandering imagination to paper; watch it take shape as you create both poetry and collaged art. Part II hosts a number of poetic devices to help you settle into the world of traditional poetry. Here you will find inspiration from today's brightest poetic voices. Part III is home to the prompts that will guide you toward your very own poetic and visual pieces of art.

Designed like a journal with directives from a friend, you are meant to open up your heart to these pages. Turn to visuals when words are not enough, just never stop creating.

—**Noor**

{ Contents }

PART I

UNCOVER YOUR WRITING STYLE
9

You will start with some general writing prompts to warm up your words and spark creativity. Forget everything you know about writing before you turn the page. Write unapologetically and fearlessly. Start to explore collage by saving up scraps of paper, digital and tangible imagery, napkin doodles, and anything that visually catches your eye.

PART II

DISCOVER POETIC DEVICES
61

It's time to explore traditional poetry forms. Inspired by the work of many fantastic poets, this part is a treasure trove of inspiration.

PART III

FIND YOUR VOICE
111

You have written casually. You have written with poetic devices. What's left is to give your unique voice a place to shelter poetry and art. Let's do this!

**Before opening your heart to the poetry
that already lives inside of you, here are
some tips from my journey as a writer.**

✦

Make lists of all the interesting words you come
across. They can come in handy when composing
new pieces.

✦

Collect images that speak to you—screenshot them
on your phone, save them to your computer desktop,
or cut them out from newspapers and magazines. Or
you can search for a specific mood or image on social
media to plug into a specific piece of work.

✦

It's okay if you can't finish a piece in one sitting.
Give your poems and collages time to grow and take
shape. Keep returning to your pieces with more
words and ideas. Don't abandon a piece of work just
because it is not moving forward quickly.

Read a lot of poetry—from the classics to contemporaries. Subscribe to free poetry newsletters online (Poets.org has this wonderful Poem-a-Day series). Keep reading!

✦

If you love a poem, memorize it. If the poet has recorded it, listen to their recording to understand how it sounds. Notice how it feels to hear the poetry out loud.

✦

You will be introduced to seven poetic devices in Part II of this book, but don't limit yourself! Research other literary devices and poetic expressions to include in your work.

✦

Write about unusual things, mundane objects, things people wouldn't necessarily view as poetic. Make something new with an existing work of art, something found in nature, or a place you visit every day.

PART I

UNCOVER YOUR WRITING STYLE

Fill this page with your favorite verses
from poets you admire.

What makes a poem good? Bad?
List your opinions here.

A bad poem is one that tries
to be good. A poem should
not be forced to become a
poem, rather write and
decide, never force.

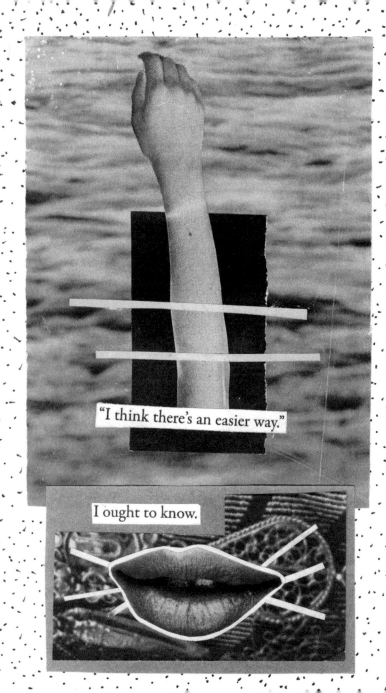

"I think there's an easier way."

I ought to know.

Finish this sentence: If tomorrow our sky
is no longer blue…

then our oceans will no longer
be deep
then we will be able to
grab a star and pluck it
from the ground
then humans will be immortal
then aliens will rule the world
then fishes will fly
then we will not be addicted to
technology like gaping apes
then politics will save lives
with clean hands
then the homeless will be
rich with money and misery
then the rich will be
poor with money and happiness
then god will answer your prayers
with words
then death will actually mean
something
then rain will be grains of sand
and salt

*Go through your phone's camera roll
and pick a random photo. Capture every
detail with words and phrases (descriptive
words for what you see, what the photo is of,
where it's from, etc.). Turn this mix of
words into a collage.*

Assign colors to people in your life.
Explain why you chose each color.
What do these colors reflect?

Mom, tu eres Verde por tener apoyo infinito para tus hijos.

Brothers, you are a mix of Purple, green, yellow, and Blue. I don't know what color they make.

Friends, You all are yellow, almost Orange. You all match each other's energy to a passionate flame of tangy oranges.

Summer Friends, you are white and Brown creating a messy mud color. I'm sure at the core, this is not the color there but your lack of communication is ugly like personalities.

Yellow,

you are crazy, energetic and that is why people want to be around you.

Purple,

you are shy, quiet and never the type to be confrontational. You're the type to sit back and watch from a safe distance

Green,

you are calm and spiritual. Wise but impulsive at times

Brown,

you have an ugly heart disguised with pretty flowers.

Blue,

you are as clear as the ocean.

White,

you are boring. Not funny but you agree to everything and that is why you have some friends

List your favorite colors and give them unique identities, outlining their personality traits and quirks as if they were real people.

Imagine if the walls of your room could talk. Record a conversation you might have with them by writing it down here.

Wall: Why do you crack your back every night before sleeping?

Because I have arthritis

Wall: You should really clean up more often, I have to see this every day

I'll do it tomorrow

Wall: You need to start taking more care for yourself

I know

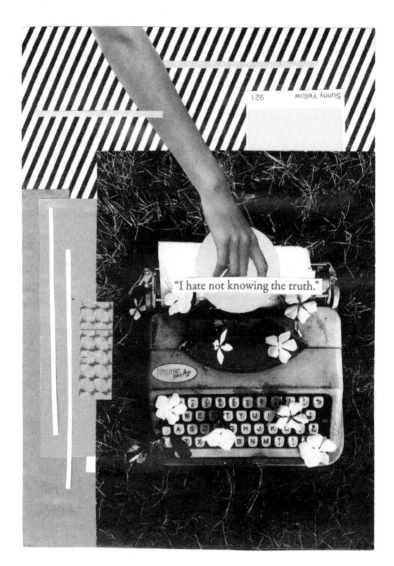

"I hate not knowing the truth."

Fill this page with quotes from your favorite movies.

*Jot down your favorite dactyls.**
Come back to this page when you
need inspiration.

*

DACTYL

A poetic meter or beat
in a line containing three
syllables: one stressed
syllable followed by two
unstressed syllables
(i.e. humanly, archetype,
etc.).

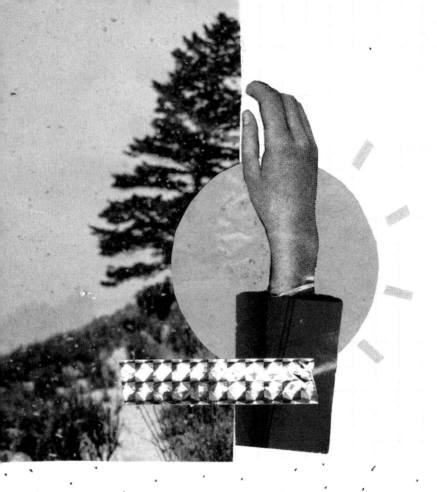

CHAPTER FIFTY-NINE

dream

Write a letter to someone who lives in the future. Include three dactyls from the previous page.

What happened in your life today?
Write a list of your day's highs and lows
and create a collage based on this list.

- Her Heart is Howling for Heat
- howling: It means a call for help
- Wolf's howl the way humans are howling for greed.
- •

Howling

Use this word in ten different sentences.

Write about your unpopular opinions.

Write for five minutes without stopping.
Don't think about any specific theme,
just let the words flow.

It's July 17 and me and the boy have decided it's better if we just call it quits. I didn't want to I wanted to kiss him right then and there. I wanted to hug him forever and draw huge circles on his back as he looks at the moon at 4 a.m. I don't know what like or love is. How it feels and how to know it's happening. I don't know if hurt is the right word but I feel like I would rather be with him here looking at the beautiful view in front of me. I forgot why I don't want to be with him. He's so confusing. He's too young to date, he knows that but he refuses to hang out with me and mess around because of what? If we're not dating and if we're not friends with benefits what the hell is it? Nothing now I guess.

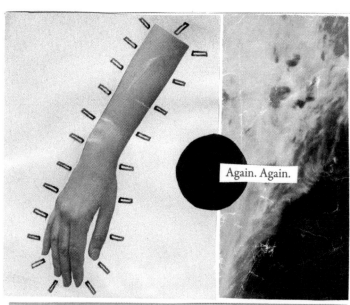

Again. Again.

blooming in the sky.

If you were to record a musical album,
what would your tracklist look like?
Write out your debut album's songs.

Finish this sentence and then keep writing: When the wolf spoke...

he told men that all their faults and weaknesses in their world with no care or concern to nature

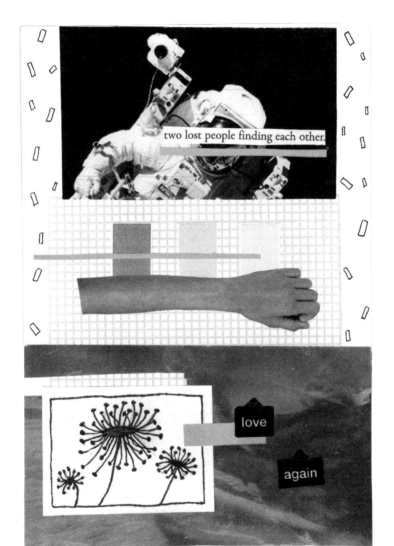

two lost people finding each other.

love

again

_You are asked to give a commencement
speech at the dream school you couldn't
attend. What would you tell the students?_

Imagine your phone has a brain.
What does it think about you? Write
down its thoughts and create a collage to
surround your words.

*Fill this space with anagrams.**
Try using ten of them in a sentence.
Ask your friends to help, too!

*

ANAGRAM

A word spelled out by
rearranging the letters of
another word; for example,
gapes and *pages*, *battle*
and *tablet*, etc.

Pick some of your favorite words and
find their translations in five languages.
Record them here.

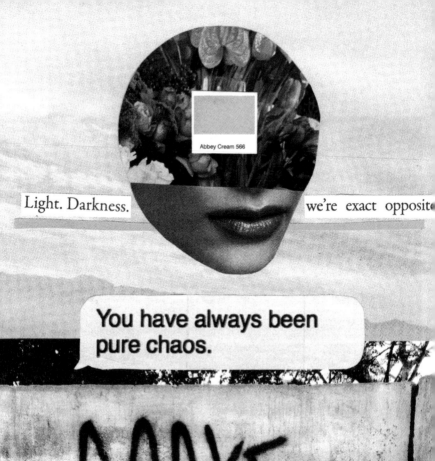

Light. Darkness. we're exact opposite

You have always been pure chaos.

Abbey Cream 566

*Imagine you have to cook a dish entirely
made up of words. What is your recipe?*

Write down your life story and keep
it contained to this page. Go!

Fill this space with your most-used slang.

_Pick a song that describes your life. Write
down the lyrics and explore how and why
they resonate with you._

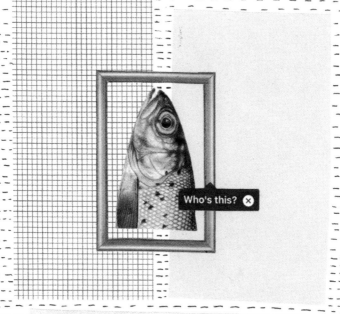

Who's this? ⊗

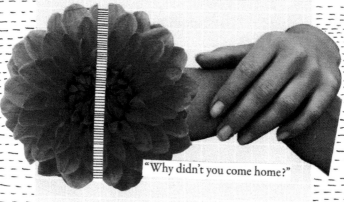

"Why didn't you come home?"

If life had gone according to the plans of your younger self, what kind of life would you be living right now? Write about it below. On the facing page, bring your words to life with a collage.

Make a list of words you just don't like.
Include the reasons why.

You have just been handed a new planet and have to make traditions and rules for its citizens. What will you do? (For example: Bright pink is one of many natural hair colors, dance parties are a routine part of the workday, or rooftop gardens on every building!)

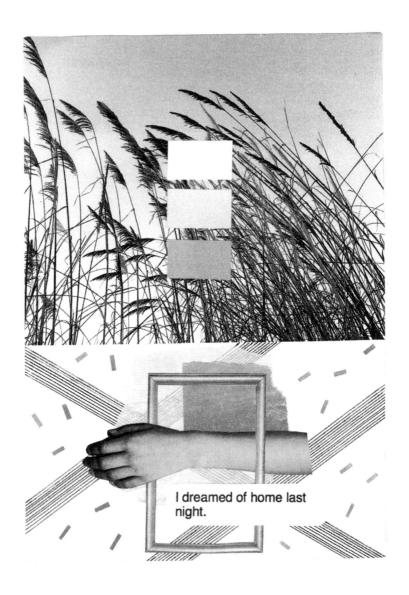

I dreamed of home last night.

Chandelier

Use this word in ten different sentences.

Write about heartbreak in the form of an official news report.

You are given a day to spend with a fictional character you abhor. What will you two talk about? Write out a conversation between the two of you.

Write about a mysterious family heirloom
that appears in your dreams.

MEMORIES LEFT ON REPLAY...

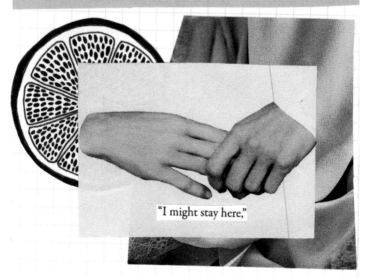

"I might stay here,"

What does your name mean? Write a history of it. Who named you? Why did they pick your name? What does it signify? On the facing page, create a collage to accompany your writing.

It sounds like the animal gazelle.

Fill this space with oxymorons.
Use your space creatively!

*

OXYMORON

A figure of speech that combines words with opposite meanings for impact—such as "jumbo shrimp" or "deafening silence."

*Finish this sentence and then keep
writing: The smell of rain . . .*

PART II

DISCOVER POETIC DEVICES

POETIC DEVICE

1

{ Prose Poetry }

Poetry is often thought of as rhythmic text with heightened imagery, symbolism, and a dreamy quality, while its grounded counterpart prose will use ordinary, everyday language to express the same sentiments. Prose poetry is where these forms of writing meet. A prose poem is written in paragraph form but exhibits a poetic quality.

FURTHER READING ✦

"Not Writing" by Anne Boyer

"In the Light of One Lamp" by Sean Thomas Dougherty

"Scheherazade." by Lucy Wainger

Write a prose poem that identifies and explores your writing habits.

Research the cultural climate during the year you were born. Craft a prose poem based on your research and what you know about your day of birth. Then, make a collage inspired by this piece.

Write a prose poem about your pet
(real or imaginary).

Write a prose poem about the last time
you were outside in the rain.

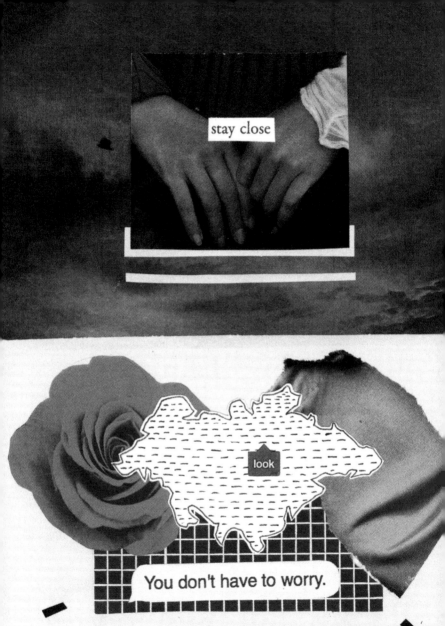

Grab a magazine, flip to a random page, and craft a prose poem based on what you see and read.

POETIC DEVICE

2

{ Found Poetry }

*Think of a found poem as a collage of words. Found poetry
is created by taking bits and pieces of text from other sources
and weaving them together to craft your own poetry. Some
poets make changes to the existing material, while others
simply string words and phrases together.*

*Found poetry is an inventive way to practice playing
with words. These poems use material from sources that
aren't necessarily poetic themselves, but the arrangement
of words can be transformative.*

**FURTHER
READING**

✦

"An Unemployed Machinist" by John Giorno
"Found Poem" by Howard Nemerov
"National Laureate" by Robert Fitterman

Write a found poem using words, phrases,
and passages from the last book you read.

Write a found poem using words, phrases,
and passages from today's newspaper.

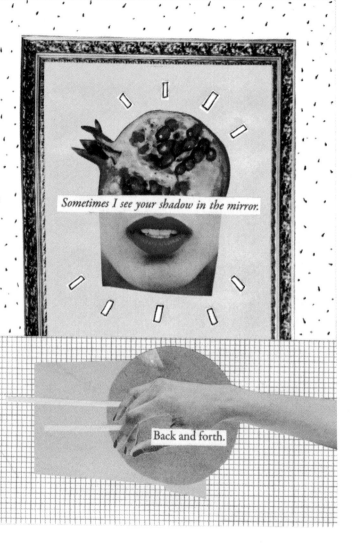

Write a found poem using words or
phrases pulled from your social media
timeline(s).

_Write a found poem with song lyrics from
your favorite musical artist's discography._

POETIC DEVICE

3

{ Anaphora }

*Anaphora is a device that uses repetition to create rhythm
and emphasis within a poem. This tool is often used in
professional or political speeches to motivate listeners; in prose
and poetry, the use of anaphora can evoke emotion while
persuading or inspiring a reader.*

**FURTHER
READING**
✦

"Here" by Arthur Sze
"London" by William Blake
"Some Feel Rain" by Joanna Klink

Write a poem about your religious and/or political views using anaphora.

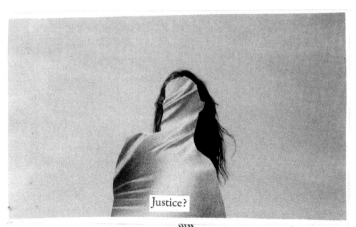

Justice?

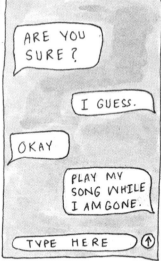

ARE YOU SURE?

I GUESS.

OKAY

PLAY MY SONG WHILE I AM GONE.

TYPE HERE ↑

*Use anaphora in a poem about falling
out of love.*

Use anaphora in a poem about your favorite childhood bedtime story. On the facing page, create a collage in response to your poem.

Write a poem about long-distance friendships/relationships using anaphora.

POETIC DEVICE

4

{ Abecedarian }

*The traditional definition of abecedarian as a literary
device is when prose or poetry is arranged alphabetically
(for example: the first letter of each line or stanza follows
an alphabetical sequence). The best part about this device
is that it remains in your creative control—some poets
organize their work loosely around the letters of the alphabet.
Read the suggested poems below to get a sense of the
different ways to use this device.*

**FURTHER
READING**
✦

"A Poem for S." by Jessica Greenbaum
"Alphabet Street" by Randall Mann
"Half-Abecedarian for Almo" by Safia Elhillo

Use the principles of an abecedarian poem to write about your high school experience.

Write an abecedarian poem about your
ideal summer.

Write an abecedarian poem describing the current aesthetic of your Instagram account.

away

out of sight

Black

941

Write a poem about the feeling you get
when you arrive at a train station, bus
station, or airport. Use the alphabet as a
way to loosely organize your poem.

POETIC DEVICE

5

{ Epistle }

*An epistle is a letter written in poetic verse, often
addressed to someone (or something!) close to the poet's heart.
Epistles always help in conveying emotions on a personal
level, adding a level of intimacy to a poet's work.*

**FURTHER
READING**
♦

"Dear March—Come In (1320)" by Emily Dickinson
"Letter to Borges from London" by Stephen Kuusisto
"Love Poem to Be Read to an Illiterate Friend" by
Tess Gallagher

Write an epistle to someone with whom
your friendship has dissolved.

Choose a personal struggle—something you're currently dealing with. Write an epistle to your struggle on this page. On the facing page, create a collage in response to your letter.

Write an epistle to your first memorable
childhood crush.

VOLUME

the center of the storm.

POETIC DEVICE

6

{ Ghazal }

*The ghazal, originally found in Arabic poetry focused
on love and romantic loss, has a specific structure and
rhyme scheme. A ghazal is composed of five to fifteen couplets,
each of which ends with the same word or phrase. (A couplet
is a pair of metered lines joined together by a rhyme.)
The word or phrase at the end of each couplet is preceded
by a rhyming word, and the last couplet always includes
a proper name—usually the poet's.*

**FURTHER
READING**
♦

"Hip-Hop Ghazal" by Patricia Smith

"Rain" by Kazim Ali

"Tonight" by Agha Shahid Ali

Write a ghazal about heartbreak.

Write a ghazal about your childhood
hometown in the fall.

Write a ghazal about the differences between
you and your parents or parental figures.
On the facing page, create a collage in response
to your poem.

Stay. Stay here.

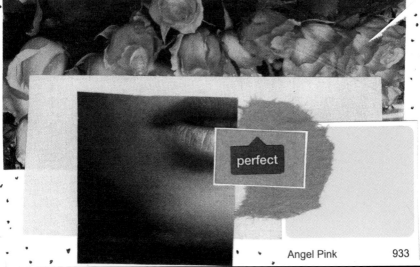

perfect

Angel Pink 933

POETIC DEVICE

7

{ Free Verse }

Free verse gives a lot of liberty to the writer, making
this poetic device like a bright white canvas. There is no
specific structure to free verse—no meter, no rhyme scheme,
no syllable count. Free verse poetry tends to follow the natural
rhythm of speaking. Much of the lyric poetry (first-person
poetry that expresses emotions) written in the twentieth
century was written in free verse.

FURTHER
READING
✦

"Essay on Craft" by Ocean Vuong

"Oil" by Fatimah Asghar

"Portrait of the Alcoholic Floating in Space with
Severed Umbilicus" by Kaveh Akbar

*Write a poem in free verse addressing a
social issue you feel passionately about.*

Write a poem in free verse about your family history. On the facing page, create a collage to go with your poem.

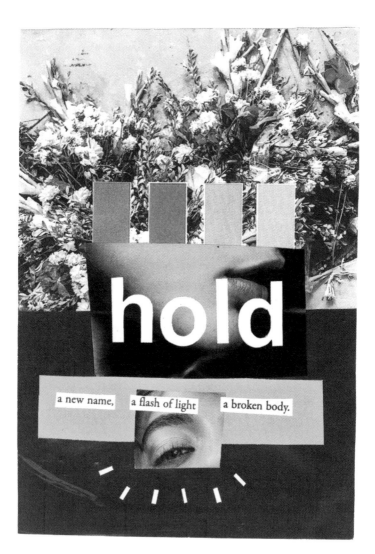

hold

a new name, a flash of light a broken body.

Write a poem in free verse about falling in love.

It doesn't exist. At least for me now. Falling in love might have been playing tag in the park in the middle of the night. It might have been laying on the top of a lifeguard stand staring at the water until the moon turned orange and the sky looked a like a rainbow of orange, purple, and pink. It might have been playing with this boy's hair as he carried on conversation about the universe and nothingness. Maybe it was kissing for the first time at the top of the planetarium. Maybe it was hearing please don't go by mike posner and jamming out like no other. Maybe it was laying in bed and turning over to see him next to me as he hugged me. Maybe it was me playing with him the whole time and never actually feeling anything.

PART III

FIND YOUR VOICE

Write a poem using three of the following words: lilac, storm, ribs, hope, stairs, fingers, gray, mild, cotton. Come back to this page at another time and choose three different words.

*Write a poem about what a day without
sound might feel like. Use a poetic device
from Part II.*

Write a poem inspired by the last song
you listened to.

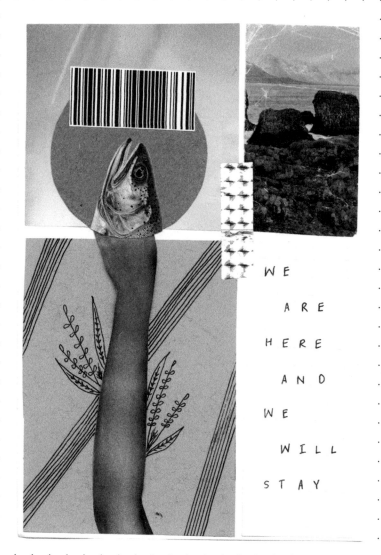

WE

ARE

HERE

AND

WE

WILL

STAY

Imagine: One day, two of your favorite
fictional characters come to life. Write a
poem about it.

Write a poem including the line "we borrowed history."

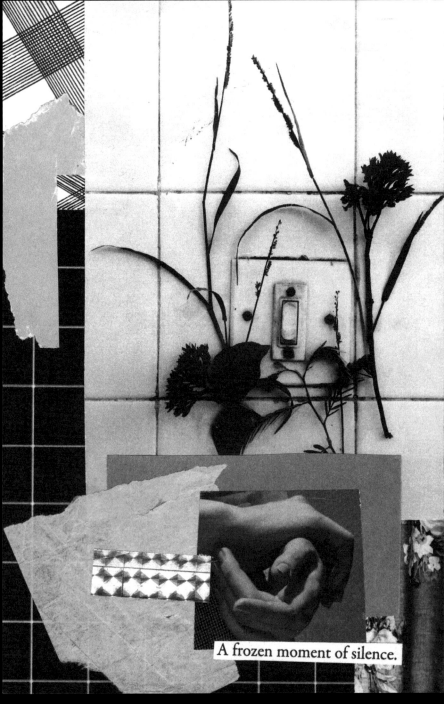

A frozen moment of silence.

_Write a poem in which you repeat the
word_ pale _three times._

*Write a poem using all of the following
words: wolf, room, grief, light.*

Recall a sunset you couldn't capture on camera. Describe it in a poem.

Grab a book near you and turn to page fifty. Find a few inspirational lines and use them as a starting point for a new poem.

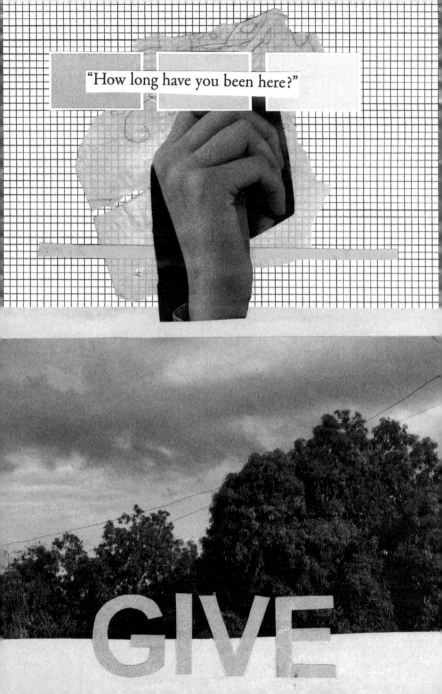

Describe two features from your favorite
pop star's face, then write a poem based
on them.

Write a poem about a clock that only
works backward. Use a poetic device from
Part II.

Envision a night when the sky dusts off everyone's thoughts at the stroke of midnight. Use this page to write a poem about it. Use the facing page to make a collage inspired by this piece.

Write a poem using the ocean as a metaphor for change.

Imagine: A fictional character you love becomes your BFF. Write a poem for them.

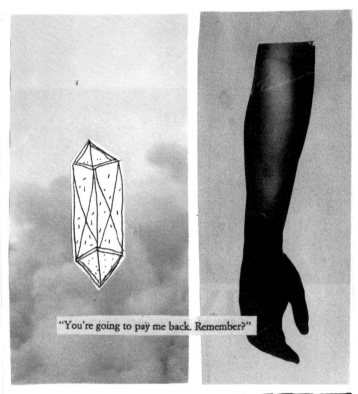

"You're going to pay me back. Remember?"

SILENCE

VIOLENCE

AMBIVALENCE

Write a poem including the line "dead flowers are talking."

Write a poem inspired by your favorite painting (for example: The Starry Night *by Vincent van Gogh [1889] or* Stars *by Agnes Martin [1963]).*

Write a poem using three of the following words: crimson, anguish, drop, cup, quest, wrath, emerald, floor, keys. Come back to this page at another time and choose three different words.

Life is like delicate china with many cracks. Imagine what these cracks look like and fill them with words and visuals. Use these pages to create a collage and a poem.

_Write a poem inspired by a fairy tale,
ancient myth, or folk story._

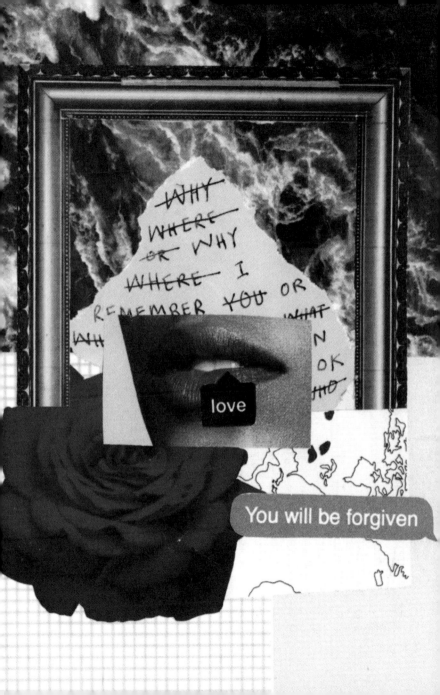

Write a poem about a day in the life of
"Alternate Universe You." Use a poetic
device from Part II.

Write a poem using three of the following words: dew, existence, darkness, hair, gold, salt, vulture, flames, marble. Come back to this page at another time and choose three different words.

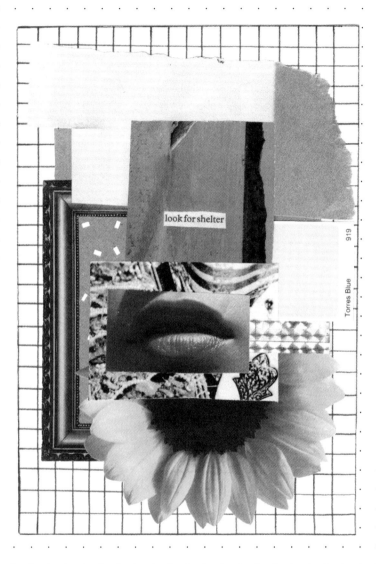

look for shelter

Torres Blue

919

List some things you adore about your hometown. Transform your list into a completely unrelated poem.

Write a poem in which you repeat the
word light *three times.*

Imagine you are a character in your favorite book or movie. Describe your life in a poem.

Write a poem including the phrase
"the ache was only a mirror."

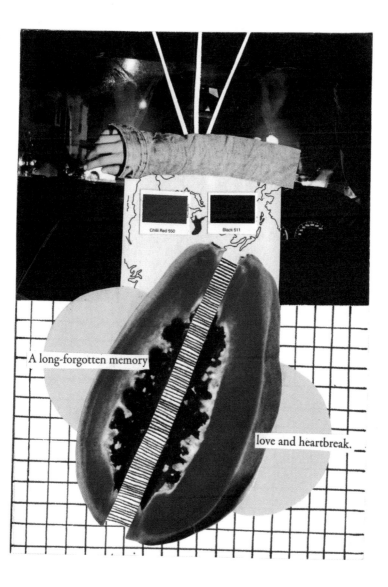

*Write a poem about your hopes and
dreams. Make a collage inspired by
this piece.*

Write an angry poem about a villainous fictional character.

Write a poem using all of the following words: decay, glory, moon, stone.

List all of the things you adored about a
former crush. Transform your list into
a poem.

CHAPTER FIFTY-SEVEN

where had you been dear where had yo
whe where ha
where ere had
where re had

where where

where here ha
where had you been dear

"And then you came home..."

Close your eyes. The first thing you see is
your subject for a new poem. Write it. Use
a poetic device from Part II.

Write a poem describing the emptiness
felt after losing a loved one.

Just a few moments more.

RISE

Make a list of the names of your favorite flowers. Now, write a poem that includes all of them.

Write a poem describing a family
tradition you particularly enjoy.

What is your favorite word? Write a
poem starting with that word and ending
with it.

Write a poem about an event that changed
you as a person. Create a collage to go
with it.

All rights reserved.
Published in the United States by Clarkson Potter/Publishers,
an imprint of the Crown Publishing Group, a division of
Penguin Random House LLC, New York.
crownpublishing.com
clarksonpotter.com

CLARKSON POTTER is a trademark and POTTER with colophon
is a registered trademark of Penguin Random House LLC.

ISBN 978-0-525-57603-7

Printed in the United States of America

Book design by Danielle Deschenes
Cover design by Lise Sukhu
Interior and cover art by Noor Unnahar

10 9 8 7 6 5 4 3 2 1

First Edition